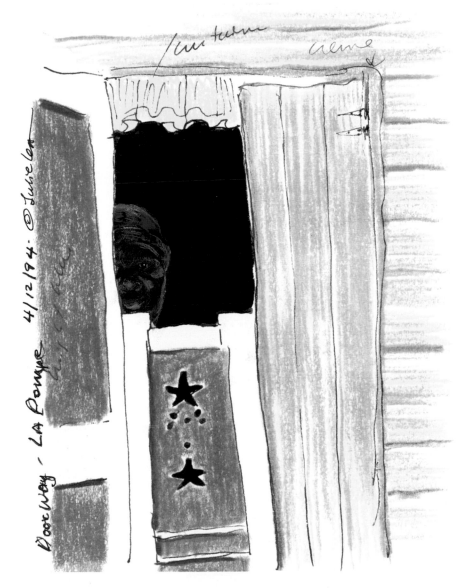

Door Way - La Pompe 4/12/94. @Julie Lea

Bequia Reflections

AN ARTIST IN THE CARIBBEAN

Julie Savage Lea

CARIBBEAN

First published 1999 by
MACMILLAN EDUCATION LTD
London and Basingstoke
Companies and representatives throughout the world

ISBN 0–333–73838–1

10 9 8 7 6 5 4 3 2 1
08 07 06 05 04 03 02 01 00 99

This book is printed on paper suitable for recycling and made from fully managed and sustained forest sources.

Formatted by CjB Editorial Plus

Printed in Hong Kong

A catalogue record for this book is available from the British Library.

Illustrations by Julie Savage Lea
Back cover photograph Janelle Kuhn

DEDICATION

To my sons, Ben and Zack, who lead the way

Acknowledgements

My deepest gratitude goes to:
Douglass Lea, my husband, for his love and patience; to Lavinia Gunn, my friend, for her gracious hospitality and enthusiasm;
to Candace Leslie of Spring on Bequia Hotel, Otmar Schaedle of Old Fort, Reanna and Mickey Olliverre, and Nolly Simmons for being generous hosts; to Janelle Kuhn for introducing me to Bequia twenty years ago
and
to all those in Bequia – saints, heroes, brave men, strong women, characters, rascals and scallawags – living and dead – whom I have had the privilege to meet.

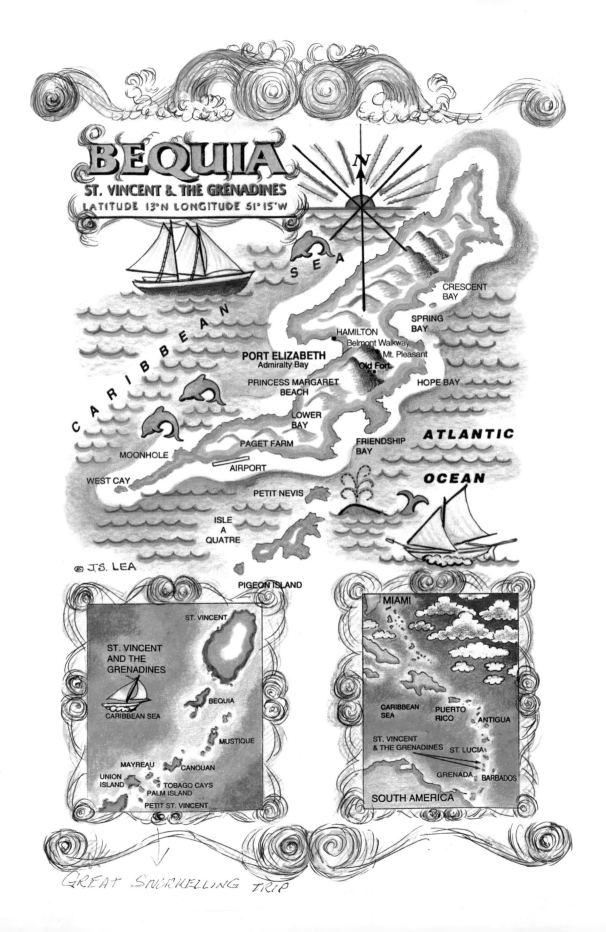

Introduction

I first saw Bequia in 1978, from the deck of a steel-hulled, 48-foot ketch. My husband and I and our two small sons were guests of young friends, part of the self-styled 'boat vagabonds', who, in those days, plied the waters of St. Vincent and the Grenadines. We arrived after a rolling, fitful, all-night sail down from St. Lucia. In the predawn light we anchored in the sheltering calm of Admiralty Bay, just off Port Elizabeth. As the others sputtered ashore in the unpredictable rubber dinghy for breakfast and a chance to shake out their wobbly sea-legs, I stayed on deck, exhausted yet dazzled by the visual feast before me.

My first response to Bequia was to pull out my watercolours and record the soft explosions of clouds and colour in the sky as a golden dawn erupted over green volcanic hills and poured into the awakening turquoise harbour.

Bequia, a Caribbean island just seven miles square, has a lengthy maritime history and proud traditions of ship-building and whaling. For centuries the tiny island has been a nexus of world-wide cultural and racial interaction. Now a destination for yachtsmen from across the world, Bequia projects both simplicity and sophistication amidst an abundance of natural beauty.

I wanted to capture the charm of what I saw that first morning – the languid parade of human and animal activity along the main street, the exotic trees and flowers, the diminutive shops and cottages, as gaily painted as the small fishing boats lining the beach. Later, I joined my family walking the rocky roads and grassy hillsides of Bequia, visiting places with names like Mt. Pleasant, Friendship Bay, Belmont, Paradise. Everywhere people greeted us with smiles.

In that brief visit, Bequia and her people cast their sweet spell on me. I have returned many times over the last twenty years, sometimes with family members, but mostly alone, to paint and sketch. These days almost all of the 'boat vagabonds' have sailed away. Sleek international yachts and cruise boats fill the harbour. Now people can also arrive by plane at the new airport. The latest technologies, for better or worse, have found their way here. There are changes, but fortunately, many are improvements that have not altered the overall beauty and small scale of the place. It is different, yet the same. Each time I return, I discover something new, about Bequia, myself and my art.

Art is a language I have been developing since childhood to communicate with myself and others. Formally trained in western artistic traditions with years of experience as a professional fine arts painter and occasional teacher, I spend the first part of each visit walking alone throughout the island at different times of the day and reflecting on what I see. During a stroll to breakfast, on the way to the post office, on a shopping excursion or trip to the beach, my artist's eye is always looking at the quality of the light, colours, shadows, contrasts, patterns – the rich visual complexity and stimulation that is Bequia. I make mental notes of subjects I want to sketch.

I prefer to work directly from life, but without attracting attention. Yet perceptive Bequians, friendly or shy, are aware of my presence. A few will stop and chat. Many have become friends and have invited me into their homes over the years. By these chance meetings, I am bound even closer to the island.

Ready to work, I carry a felt tip pen and conceal a small spiral sketch pad in the palm of

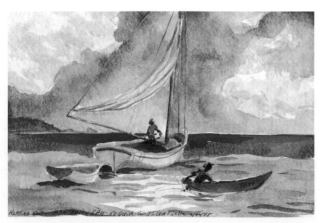

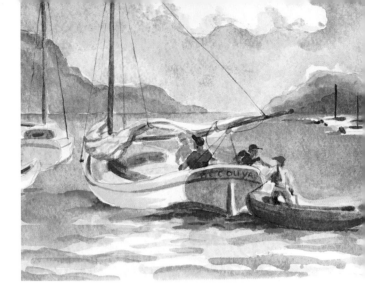

my hand. I find a hidden perch or I move along looking for subjects, usually in the morning when people are about daily tasks. I sketch rapidly, drawing only a few simple lines – a moving subject within 10 seconds, a stationary one within 10 minutes. This way the squiggles on paper capture the essence of each subject. I seldom look at the paper. Sometimes an interesting character passes by too fast, but I can recall defining features of face or figure if I work promptly.

Later, as I flesh out each sketch with pen or coloured pencil, I bring back the totality of that brief encounter. I sense the quality of light and shadow, descriptive details, exact colours, even the sounds, smells and conversations that surrounded me as I made each drawing.

Often I will gather blossom or a leaf that attracts my eye and take it to my Bequia lodgings, where I study it for hours as I draw and paint.

In Bequia, I use pen and ink, watercolour, and acrylics to create small works. When I return to my studio in Virginia, I extend my trip as I translate the sketches to larger, more finished pieces. Away from the island, yet reflecting upon the island subject matter, I plumb deeper levels of my Bequia travels, going beyond descriptive, 'postcard views' toward my experience of being there.

My unconscious mind guides me to make choices in colour, design, and perspective to recreate, in visual form, what I experience whenever I step off the ferry at Port Elizabeth. Once again, all of Bequia wraps around me. Under a brilliant sky filled with colour and movement, the glittering sea and an exotic parade of people, events, and contexts leaps at me. There is shouting and confusion – taxis, trucks, people moving about among swaying palms and bright blossoms. I am taking it in and trying to mind my step amidst the joyous flux. There is no background. All is foreground. Nothing seems diluted or receding. It is coming at me rather than coming from within me. I cease to be an artist-observer; I relinquish my academic disciplines. I feel possessed by the Spirit of Bequia. Bright colours and folk-like forms tumble out of my hands and onto the paper. Flat surfaces ripple with patterns. Acrylic colour, straight from the tubes, forms an innocently exuberant rendering of joy and beauty. Finishing such a painting some years ago, I was astonished to observe myself signing the picture, 'jolie'. These days, 'jolie' paints along with Julie, and my Bequia friends call me by both names.

I apply a variety of styles to convey my visual experiences of Bequia. I use several tools and media to create these different vantage points – pencils, pen and ink for fluidity and quick drawings and for rendering minute details; an array of coloured pencils, worked strongly in bright layers to note colours and moods; diluted watercolours to create quickly changing skies or lend a feeling of softness and mystery to a scene; brushes that range from two inches wide to tiny pinpoints that wield acrylic paint in transparent sheets of colour, in abstract patterns or in bright saturated areas to convey music, rhythm and visual delight.

I realise I can never know the total truth of Bequia. Nevertheless, I return again and again to paint the endless combinations of beauty, joy and tranquility I choose to see here. The images in this book, arranged to convey a day-long visual exploration of the island, are my reflections of Bequia. In truth, there are as many Bequia Reflections as there are people who love this island. Bequia is a special place – perhaps even a state of mind – that holds us in her spell, teaches us about life, and beckons us always to return.

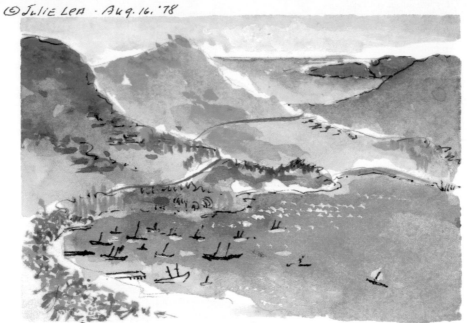

© Julie Lea · Aug. 16, '78

VIEW OF PORT ELIZABETH HARBOR from Cinnamon gardens, BeQUIA, W.I.

Bequia is one of the Grenadine Islands ...

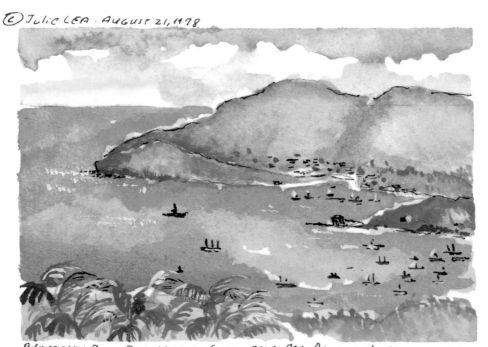

© Julie Lea · August 21, 1978

Admiralty Bay, BeQUIA, W.I. from ATOP MT. Pleasant, Barbara's House.

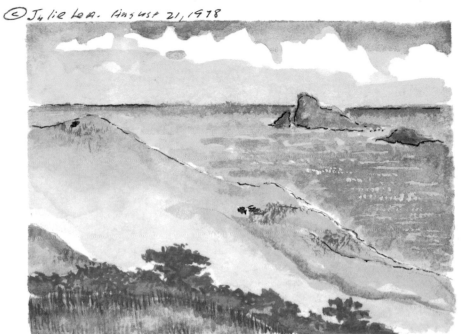

© Julie Lea. August 21, 1978

VIEW of Atlantic from Barbara's House, Mt. Pleasant, Bequia, W.I.

a tiny jewel set in the Caribbean Sea.

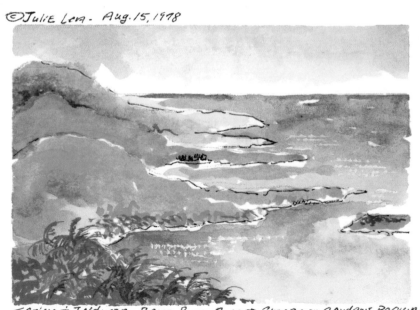

© Julie Lea. Aug. 15, 1978

Spring & Industry Bays from Road to Cinnamon Gardens, Bequia, W.I.

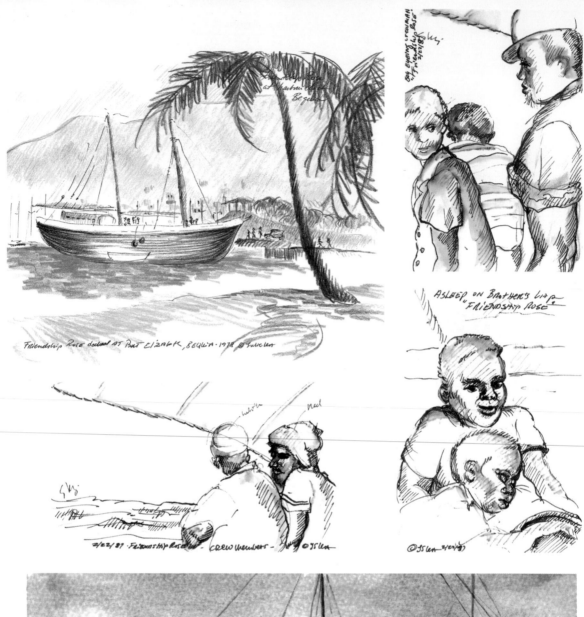

Friendship Rose docked at Port Elizabeth, Bequia · 1978 © Tucker

ASLEEP ON BROTHER'S LAP "FRIENDSHIP ROSE"

2/23/87 · Friendship Rose · — CREW MEMBERS — © J Tucker

© J Tucker 2/24/87

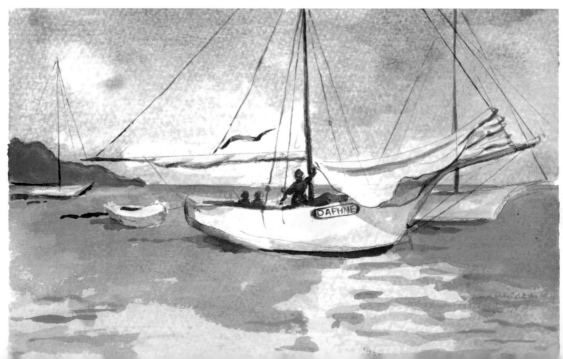

DAPHNE

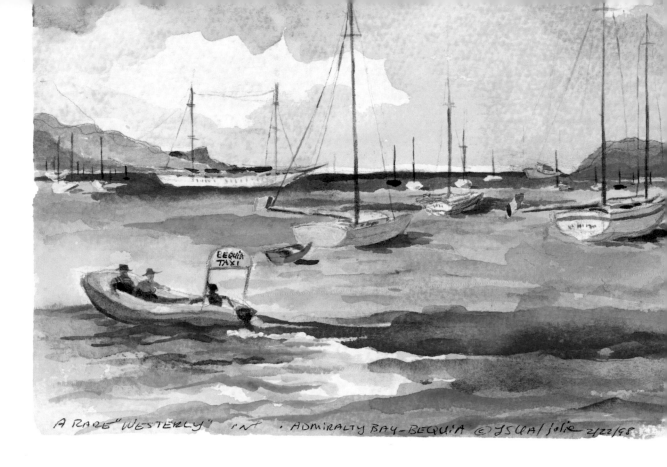

A RARE "WESTERLY" IN · ADMIRALTY BAY-BEQUIA ©JSLEA/jolie 2/22/98

For centuries, visitors have arrived by boat
to the safe harbour of Admiralty Bay.

HOW to BEAT GRIDLOCK! ©JSLEA/jolie '98

WATER TAXI - IN MEMORIAM "Jolly Joseph" ©JSLEA/jolie '98

9

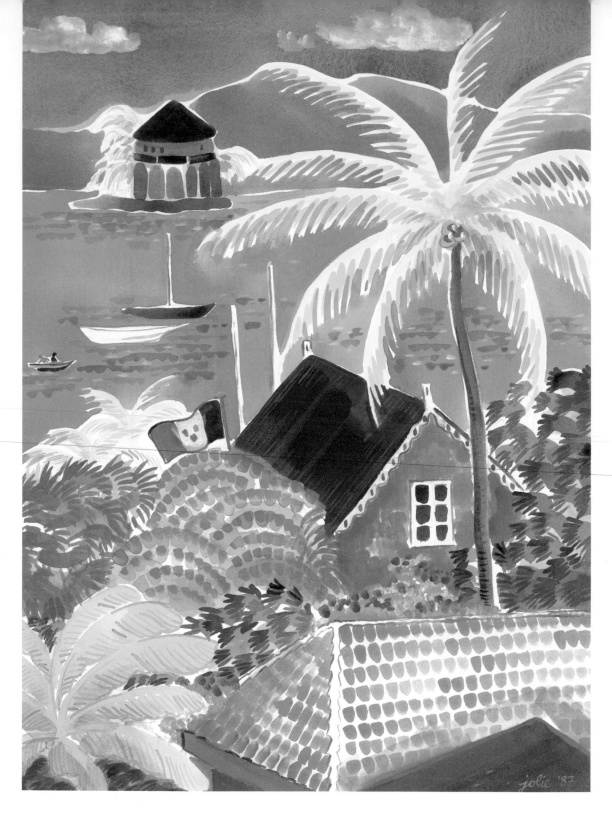

Port Elizabeth and Hamilton embrace the shoreline.

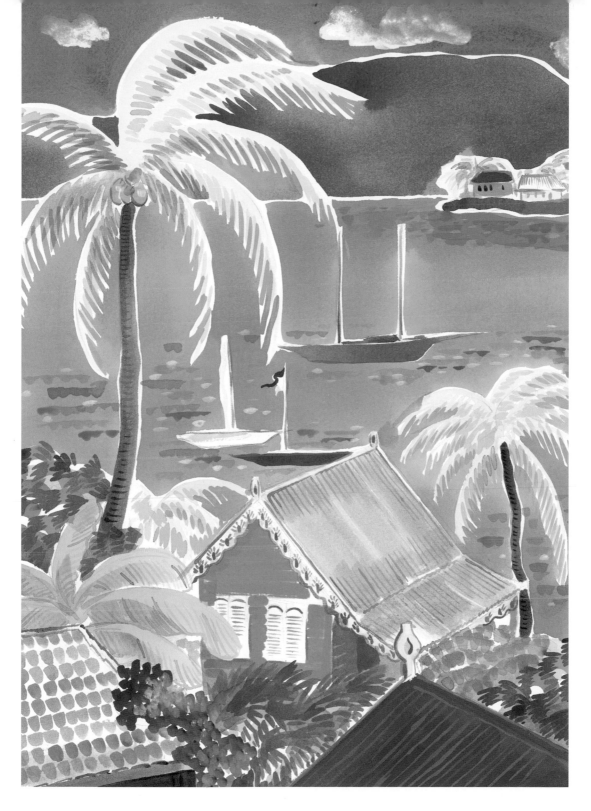

Yachts from around the world vie for anchorage here.

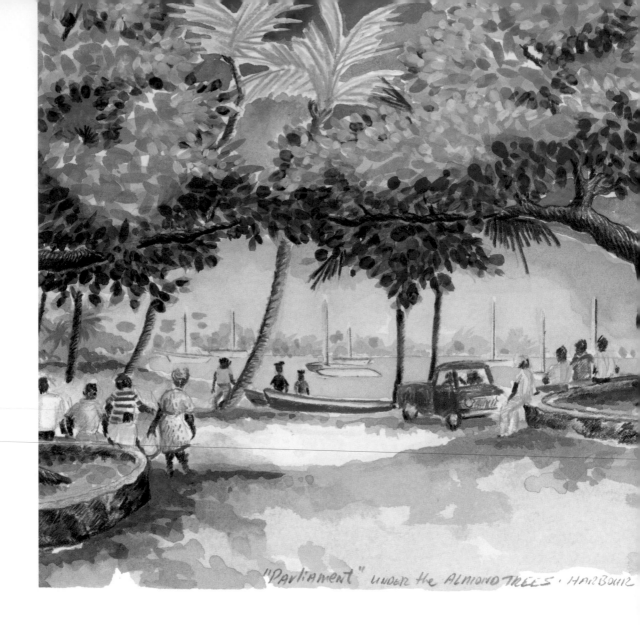

"Parliament" under the ALMOND TREES · HARBOUR

People gather at the 'House of Parliament' under the
almond trees near the harbour jetty.

STAND UP AND RIDE·FAST

©JSea/Jolie '98

CANNON & TAXI STAND
UNDER the ALMOND TREES · BEQUIA

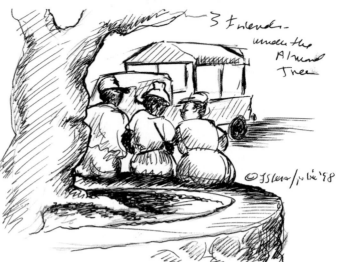

3 Friends
under the
Almond
Tree
©JSLea/julie '98

Conversation under the ALMOND TREE

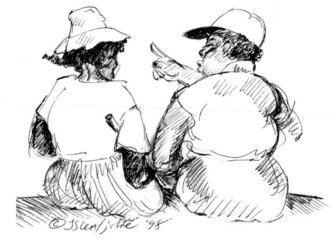

©JSLea/julie '98

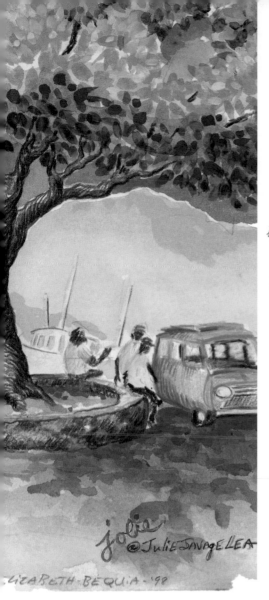

jolie
@JulieSavageLea

LIZABETH·BEQUIA·'98

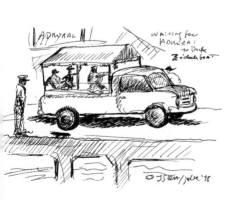

ADMIRAL

Waiting for
ADMIRAL to Dock
8 o'clock boat

©JSLea/julie '98

Retired Couple
under the
Almond Tree
©JSLEA 3/98

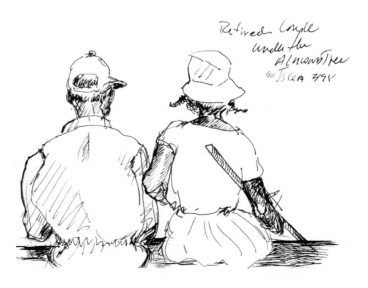

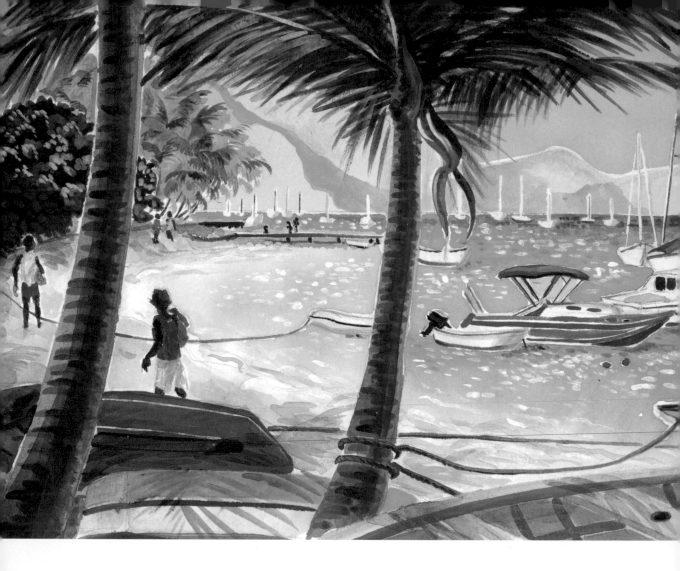

*They stroll along 'Belmont Walkway', a path by the beach,
to reach small hotels, shops and restaurants.*

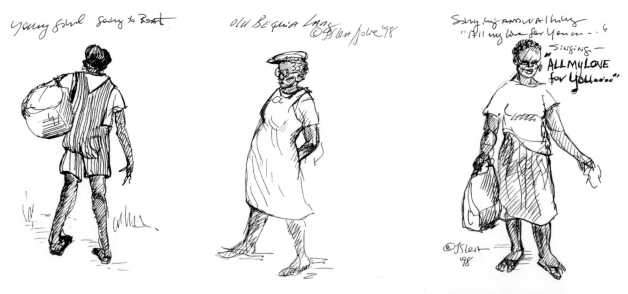

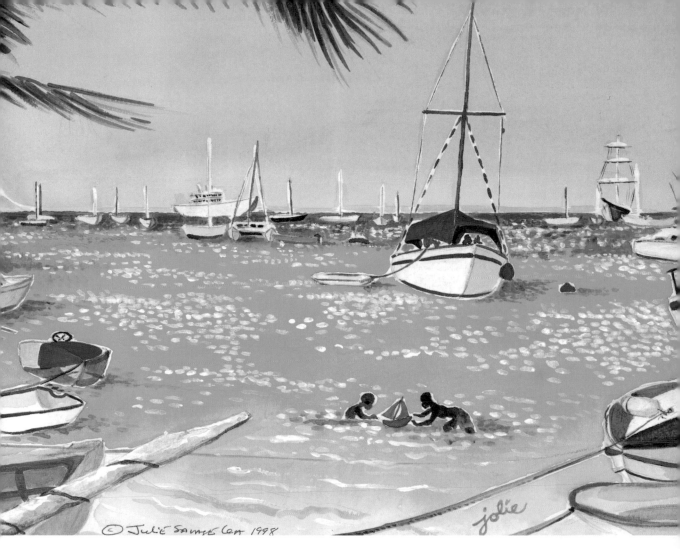

© Julie Savage Lea 1998

jolie

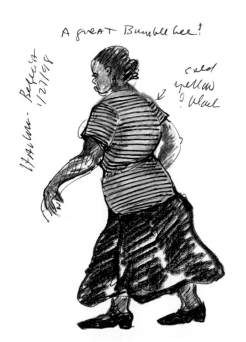

A great Bumble bee!

Harlem - Refecca
1/27/98

cold
yellow
? black

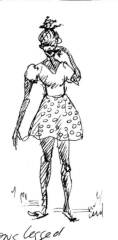

long legged
BEQUIA girl
eating a candybar
© Julie Lea/jolie '98

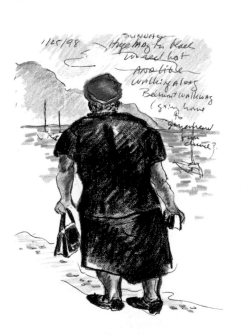

1/25/98

Sunday
Huge Mag-hi black
tweed hat
Adorable
walking along
Belmont walkway
(going home
to girlfriend
for dinner?)

15

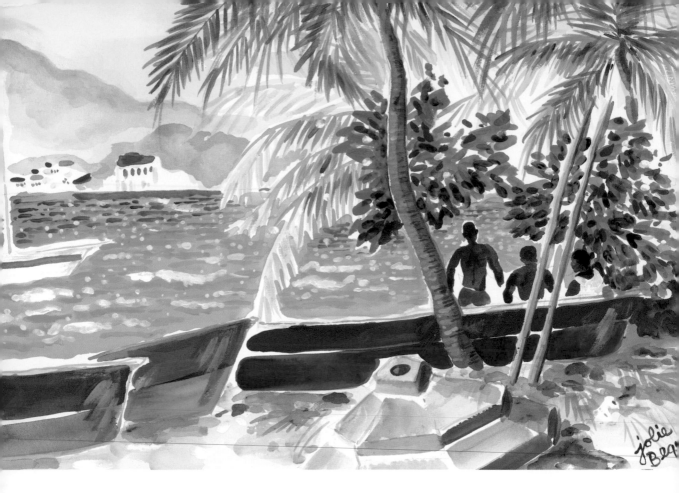

Fishing and shipping are traditional occupations.

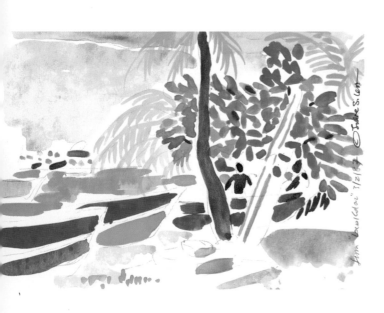

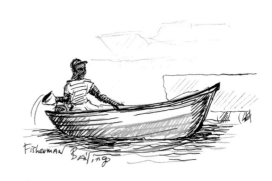

Fisherman Bailing

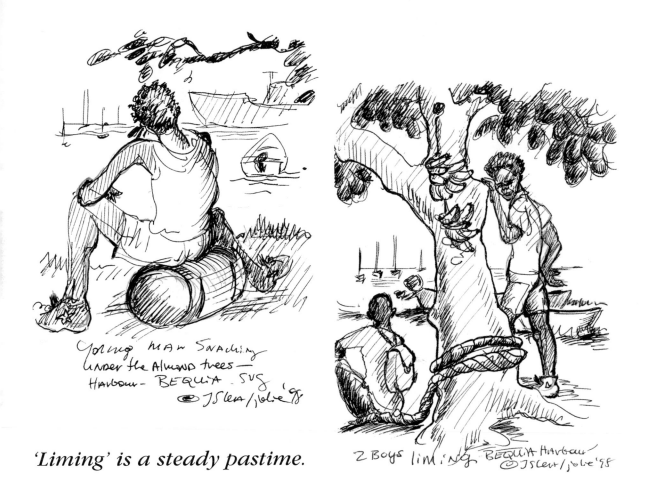

Young man snacking under the Almond trees — Harbour — BEQUIA. SVG
© JSlew/jolie '98

2 Boys liming BEQUIA Harbour
© JSlew/jolie '98

'Liming' is a steady pastime.

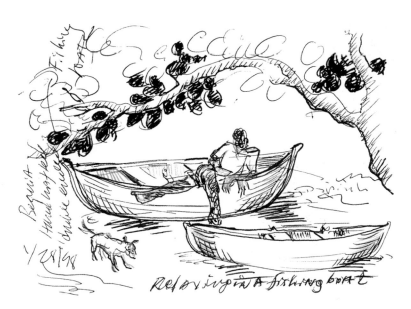

Relaxing in a fishing boat

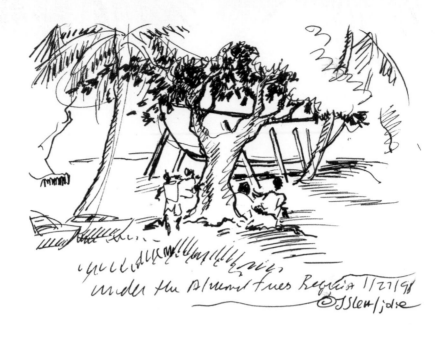

under the Almond trees Bequia 1/27/98
©JSlew/jolie

For generations Bequia men have built boats
with pride and skill from island materials.

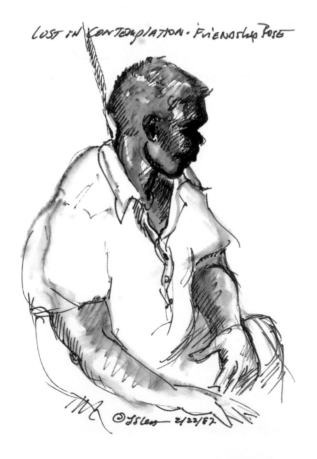

LOST IN CONTEMPLATION - FRIENDSHIP BAY

©JSlew 2/22/87

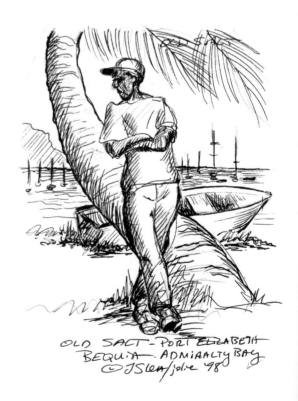

OLD SALT - PORT ELIZABETH
BEQUIA - ADMIRALTY BAY
©JSlew/jolie '98

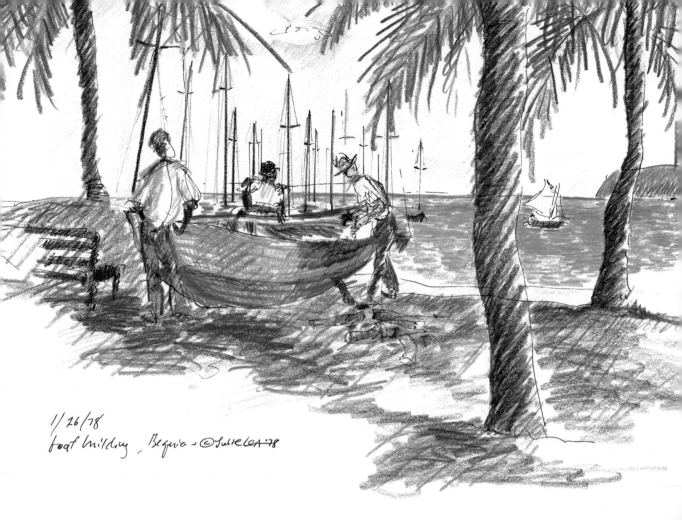

1/26/78
Boat building, Bequia - ©Julie Lea '78

In these vessels they brave the dangers of the sea.

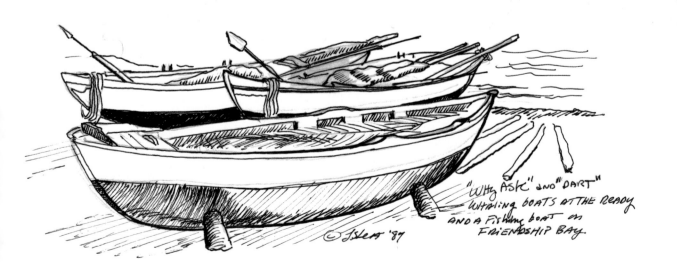

"WHY ASK" AND "DART"
WHALING BOATS AT THE READY
AND A FISHING BOAT ON
FRIENDSHIP BAY.
©Lea '87

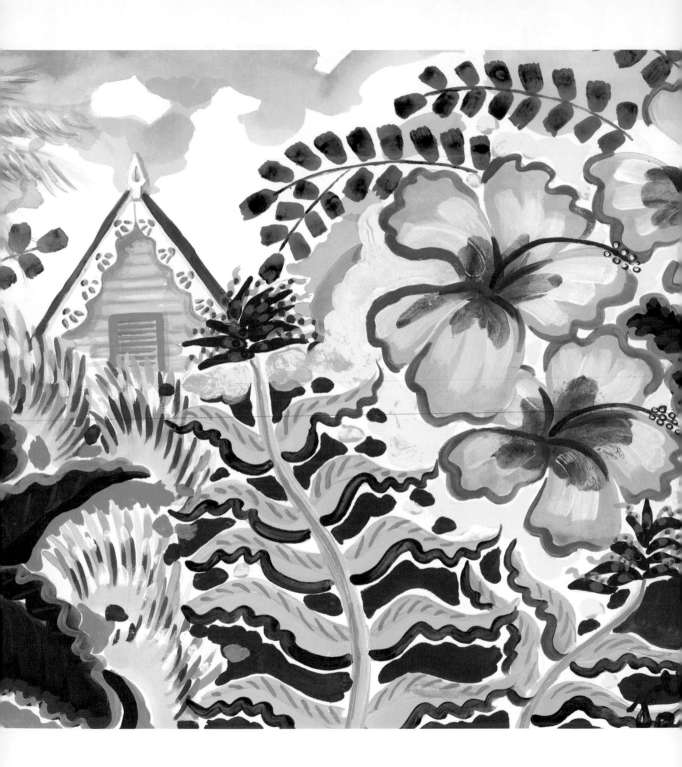

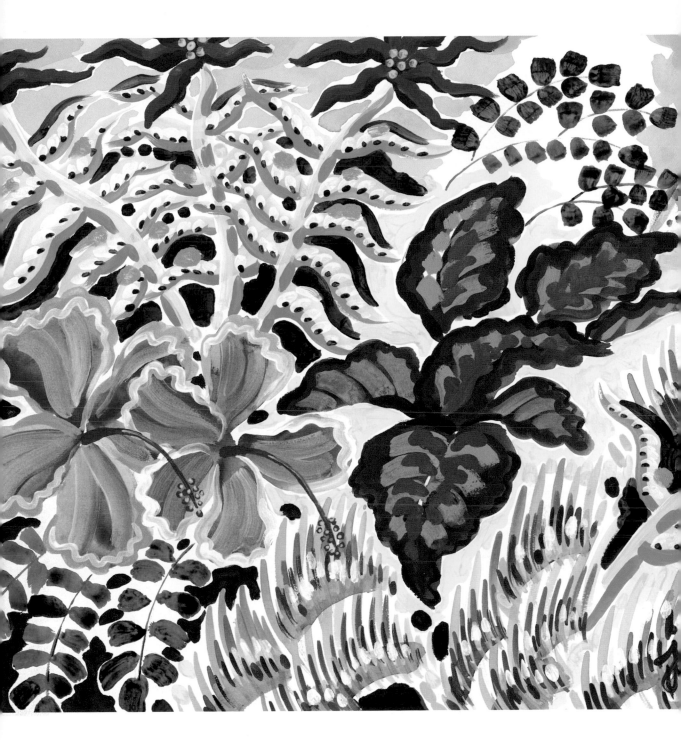

*A wealth of tropical flowers bursts forth
in tiny gardens and along roadways.*

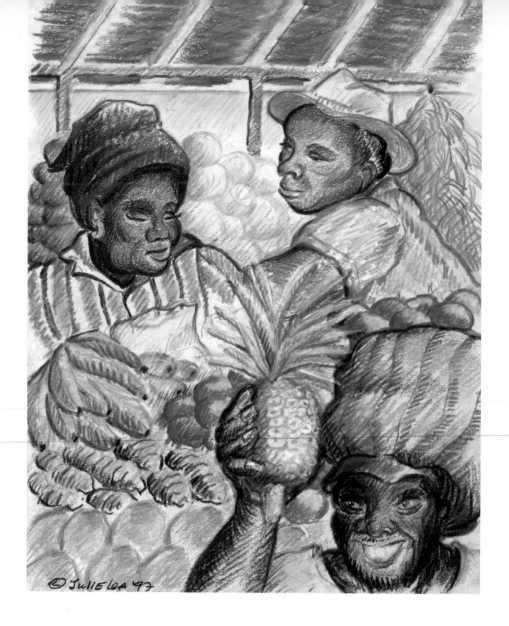

Bequia women excel as tireless entrepreneurs.

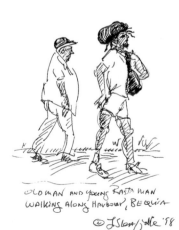

OLD MAN AND YOUNG RASTA MAN
WALKING ALONG HARBOUR, BEQUIA
© J Slow/jolle '98

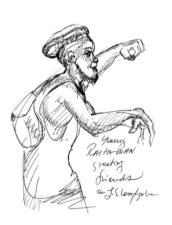

young
Rasta man
greeting
friends
© J.S.len/jolle

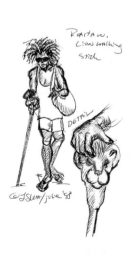

Rastaw.
Lion walking
stick

DETAIL

© J.Slow/jolle '98

They compete with young Rastas
in the lively markets of Port Elizabeth.

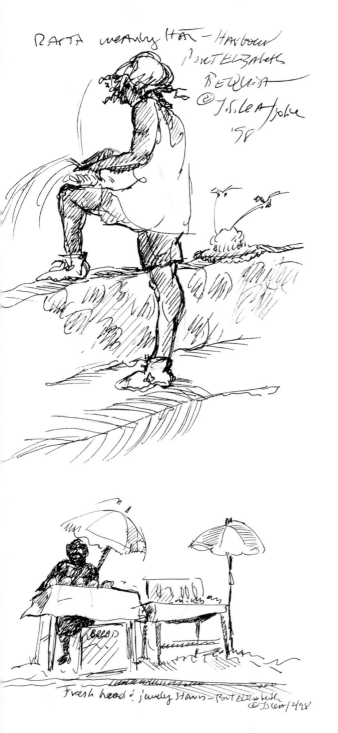

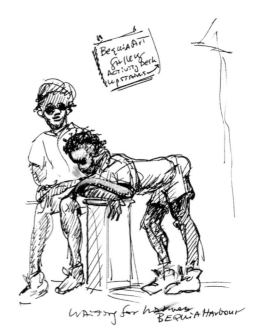

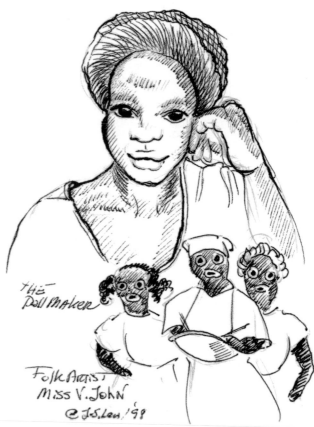

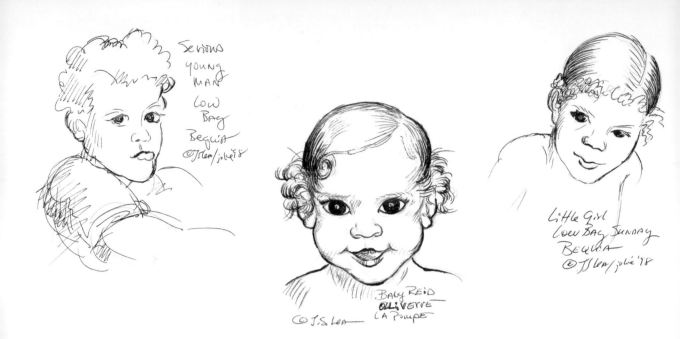

Serious
young
man
Low
Bag
Bequia
©JSLea/Julie'78

Baby Reid
Olivierre
La Pompe
©J.S.Lea

Little Girl
Low Bag Sunday
Bequia
©JSLea/Julie'78

The faces of Bequia's children reveal the cultural and racial mixtures of the island.

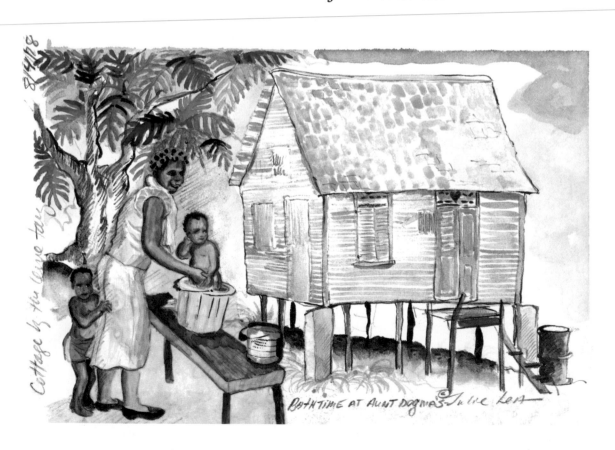

Cottage by the Lower Bay

Bathtime at Aunt Dogma's Julie Lea

Bequia Thur Aug 13, 1996 - Gingerbread House

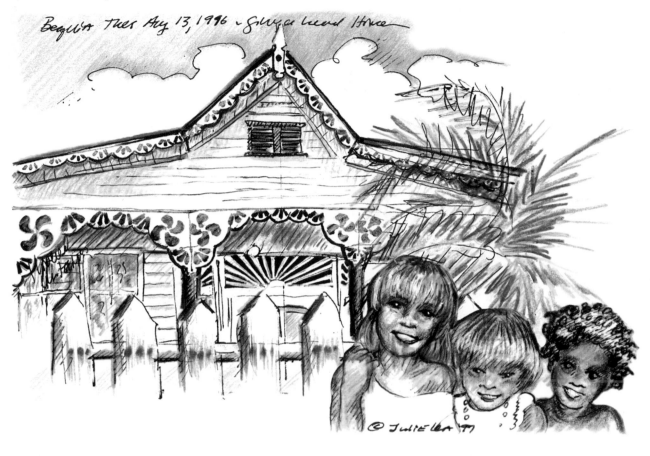

© Julie Lea '97

MODERN BEQUIA
Mother
(IN SHORTS) with
Dressed up
Daughter

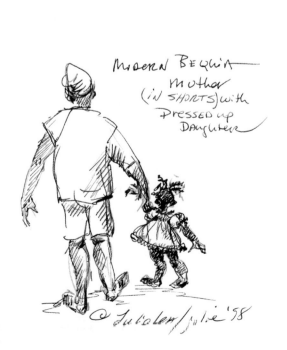

© Julie Lea / julie '98

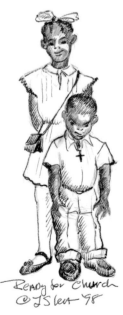

Ready for Church
© JSLea '98

At the WATER'S EDGE
Low BAY
BEQUIA
© JSLea / julie
'98

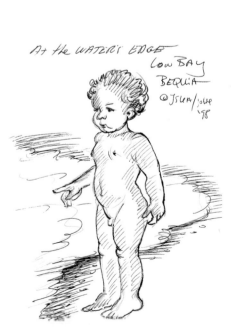

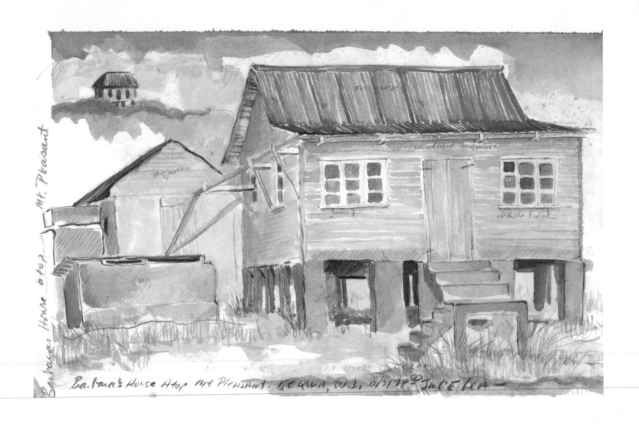

Barbara's House Atop Mt Pleasant. BEQUIA. W.I. 8/3/78 © Jul'E Lea –

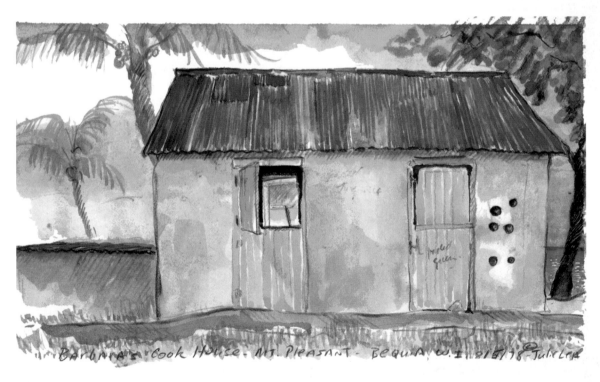

"BARBARA'S" COOK HOUSE. MT. PLEASANT - BEQUIA. W.I. 8/5/78 Jul'E Lea

EL LETE FASHION
Boutique
Center of Low Bay - Bequia
©Julie Lea/jolie '98

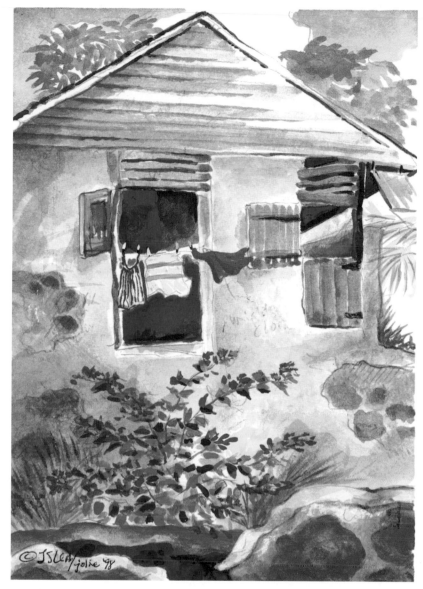

©JSLea/jolie '98

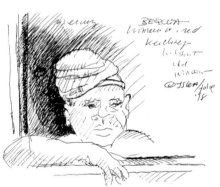

Weathered cottages and their ancient, wary inhabitants
recall an island history of hard work and survival.

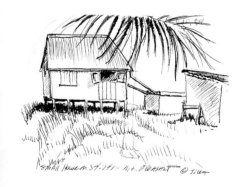

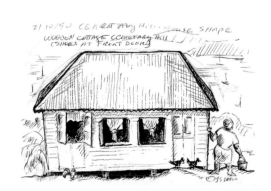

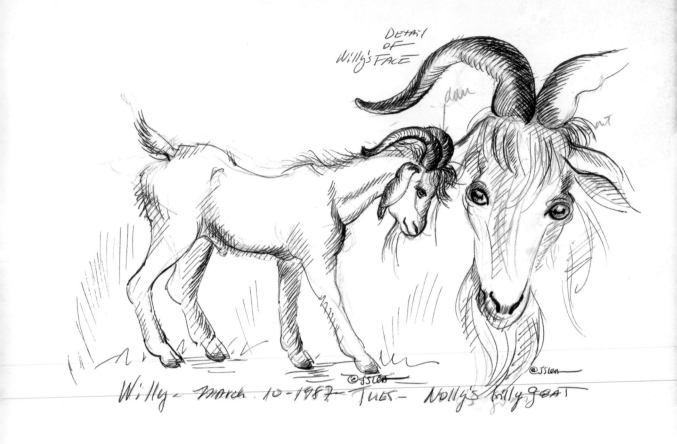

Detail
of
Willy's FACE

Willy - march 10-1987 - TUES - Nolly's billy GOAT

Here animal and human lives depend on each other.

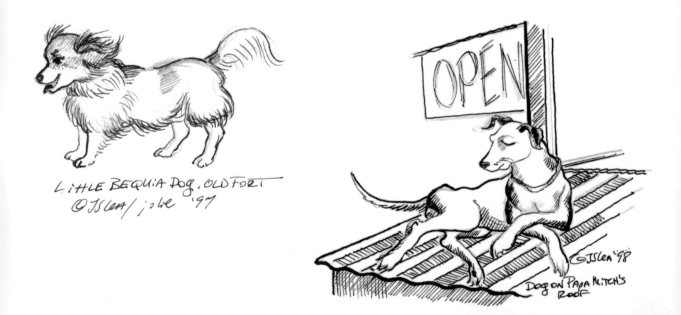

Little BEQUIA DOG, OLD FORT
©JSLea/ jobe '97

OPEN

©JSLea '98

Dog on PAPA MITCH'S
ROOF

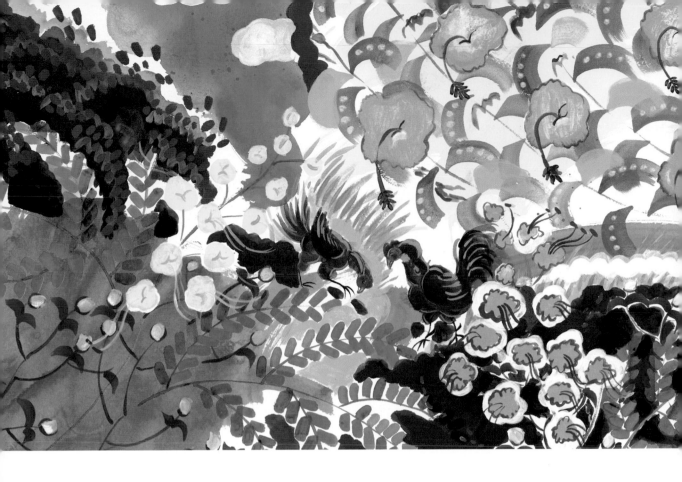

Their musical voices resonate all over the island.

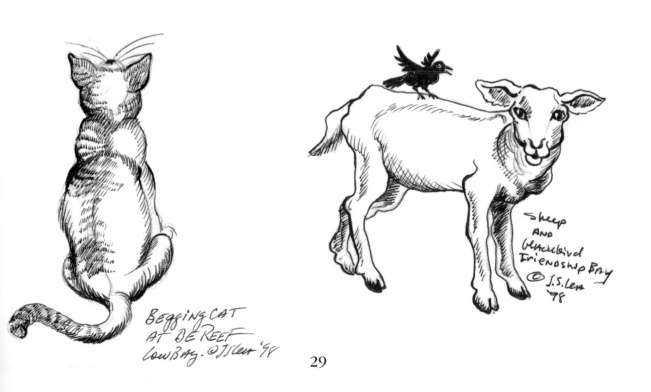

BEGGING CAT
AT DE REEF
COW BAy. ©J.S.Lew '98

Sheep
AND
blackbird
Friendship Bay
©J.S.Lew
'98

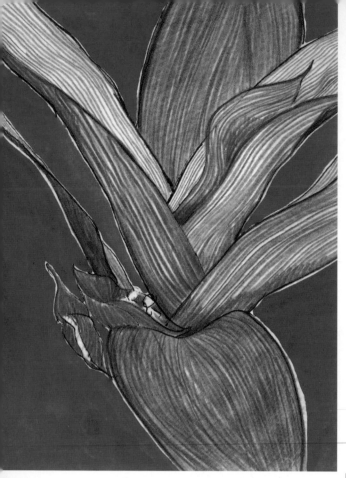

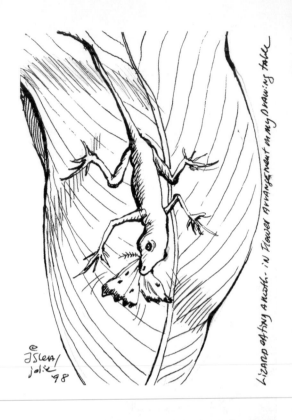

Lizard eating a moth... in flower arrangement on my drawing table.

© Islen
Jolie '98

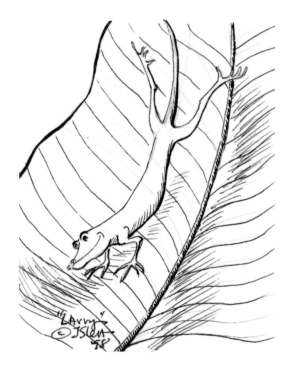

"Larry"
© Islen '98

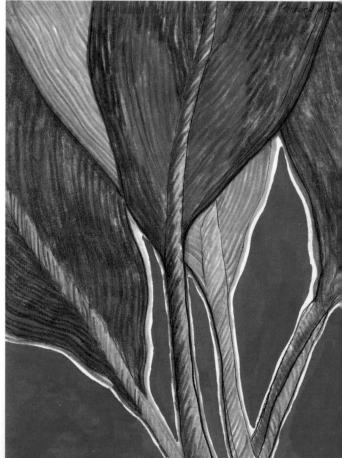

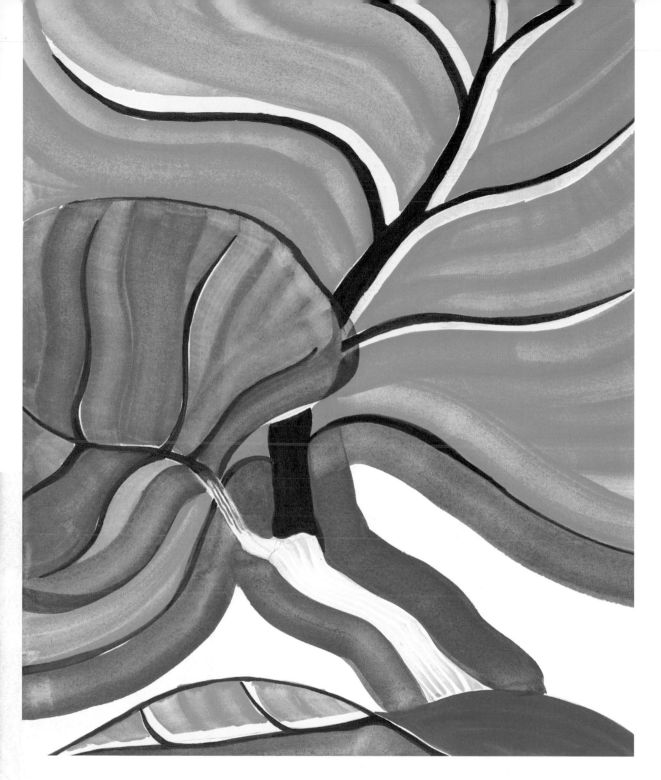

Even details of colour and patterns in the foliage express the joys and rhythms of Caribbean life.

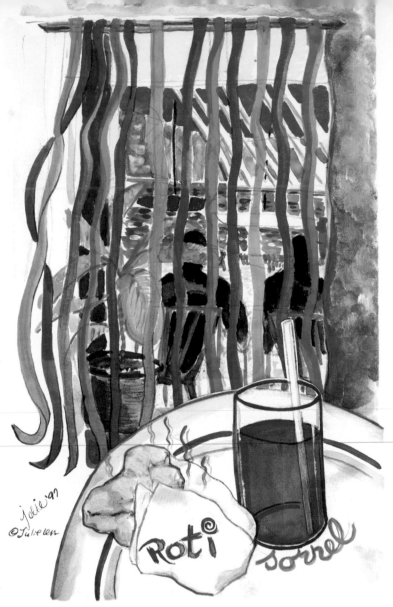

Jolie '97
@Julielen

Roti

sorrel

In every restaurant,
both grand and spare,
island food is fresh
and tasty.

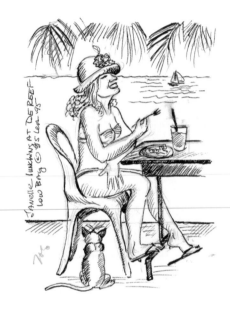

Janelle lunching at De Reef
Low Bay © JS Len '95

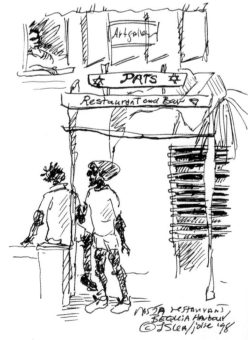

PATS
Restaurant and Bar

Pasta Restaurant
Bequia Harbour
© JSLen/Jolie '98

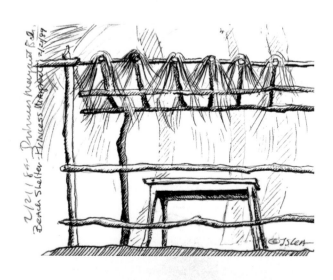

Beach Shelter Princess Margaret B.A.

© JSLen

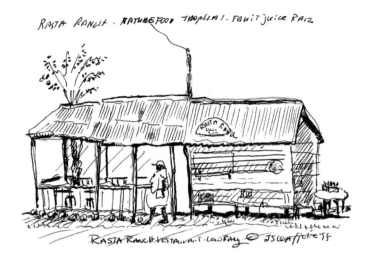

RASTA RANCH · NATURE FOOD TROPICAL · FRUIT JUICE BAR

RASTA RANCH RESTAURANT · LOWRAH © JS CAFFERIE '95

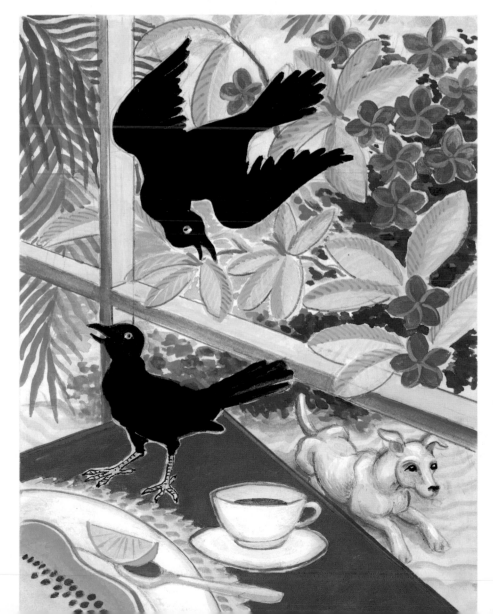

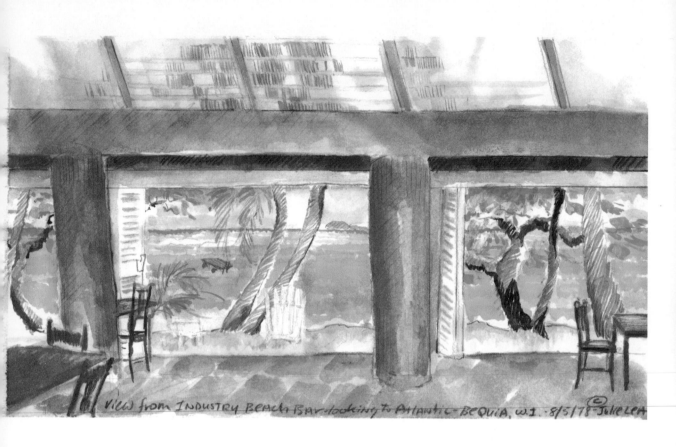

View from INDUSTRY BEACH BAR looking to Atlantic - BEQUIA, W.I. - 8/5/78 - Julie Lea

Small, family-owned hotels look out on
the surrounding sea.
Windows capture the tradewinds and ocean views.

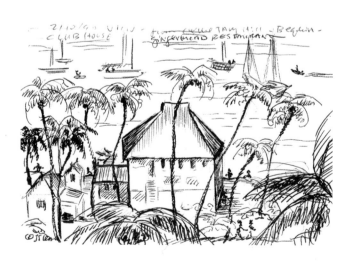

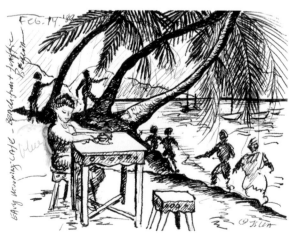

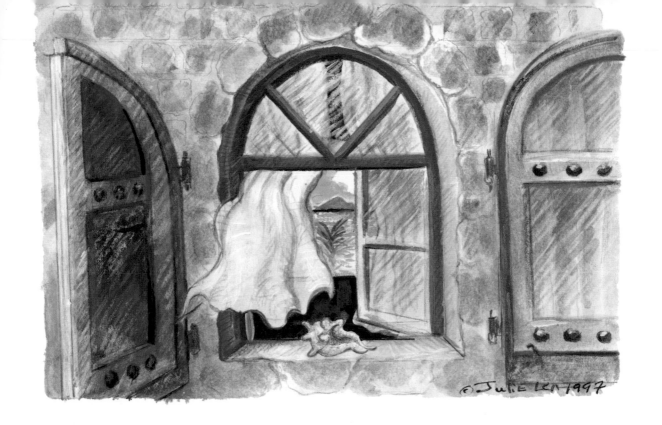

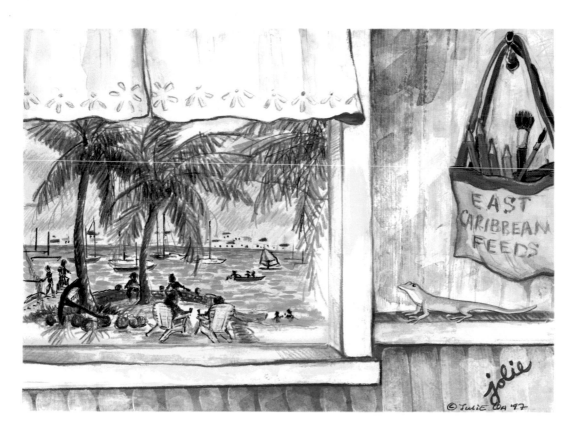

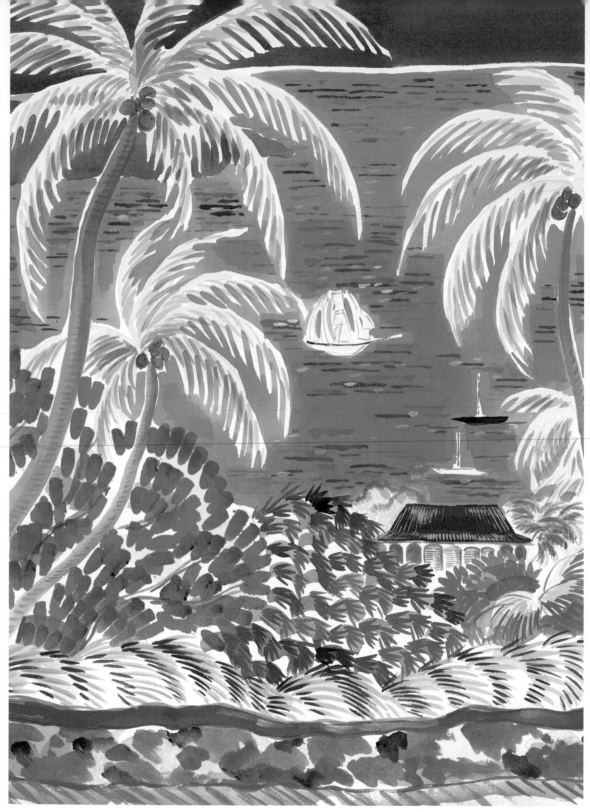

It is easy to get around the island ...

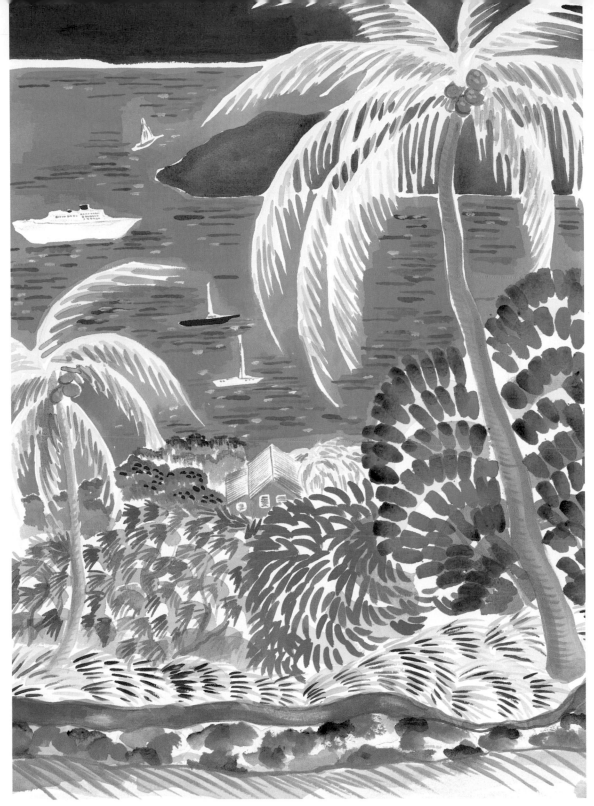

on foot, by taxis or on local 'dollar vans'.

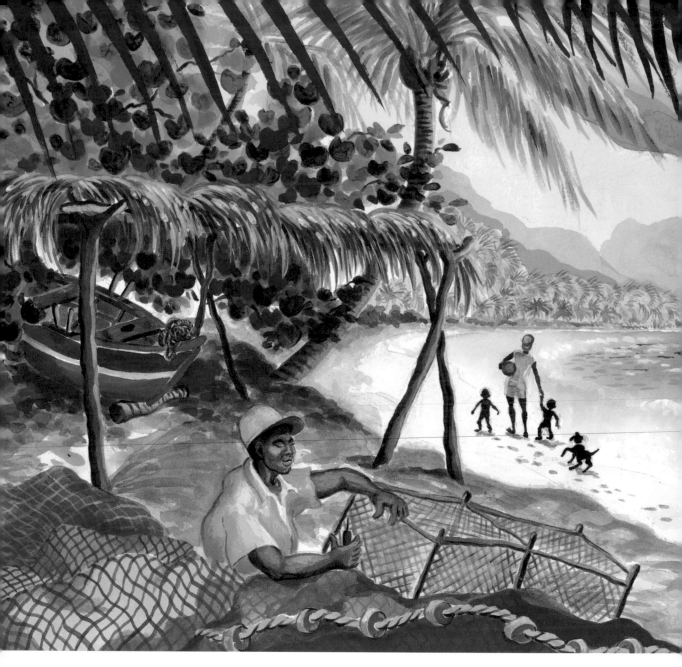

Repairing Fish Trap at Laf Bay, Bequia '98

©JSLeA/Jolie'98

©JSLeA/Jolie'98 Fish Trap

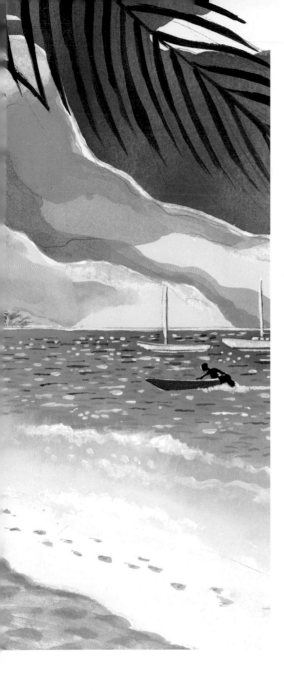

*In Lower Bay, a small
fishing settlement, sea baths
and outdoor work are
daily rituals.*

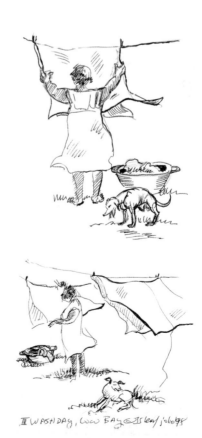

I WASHDAY, Low BAy. O.JSLEA, jolie '98

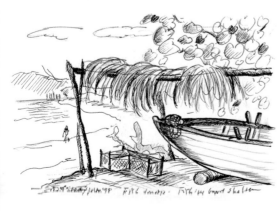

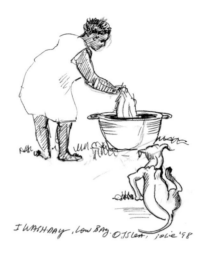

II WASHDAY, Low BAy GJSleA/jolie98

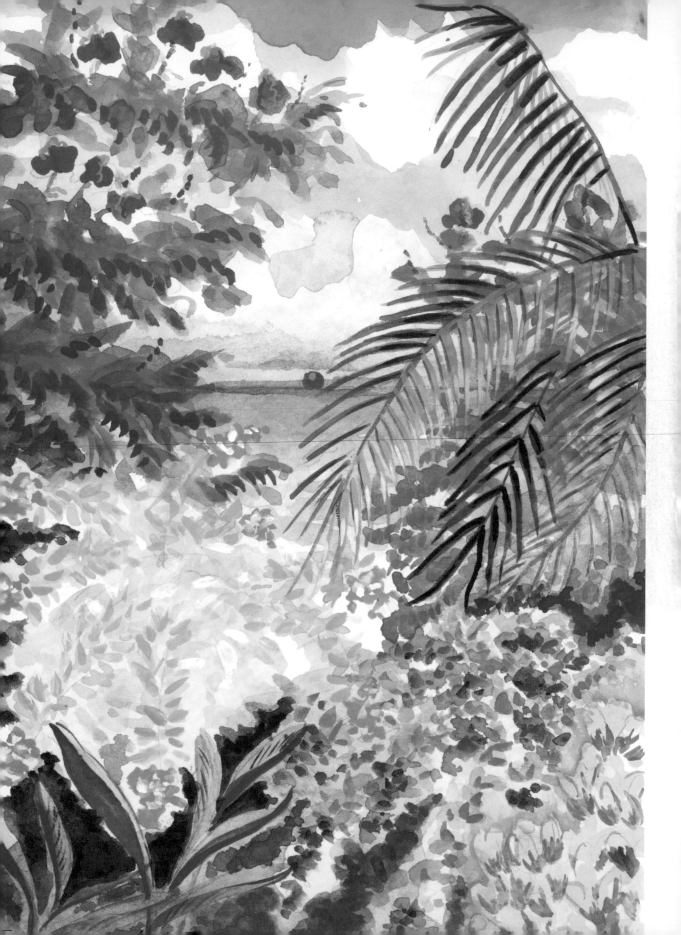

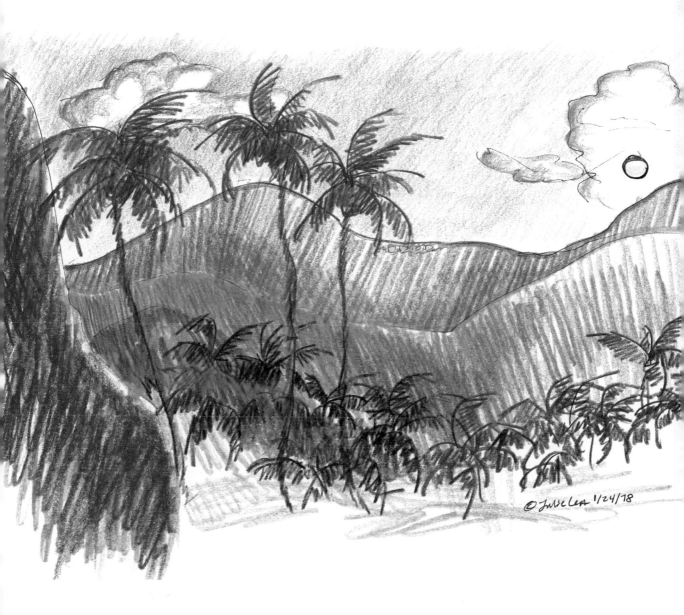

*When the sun surrenders amid a forest of blossoms,
tree frogs begin their nightly songs, bats flutter in the
twilight and a full moon rises in the velvet sky.*

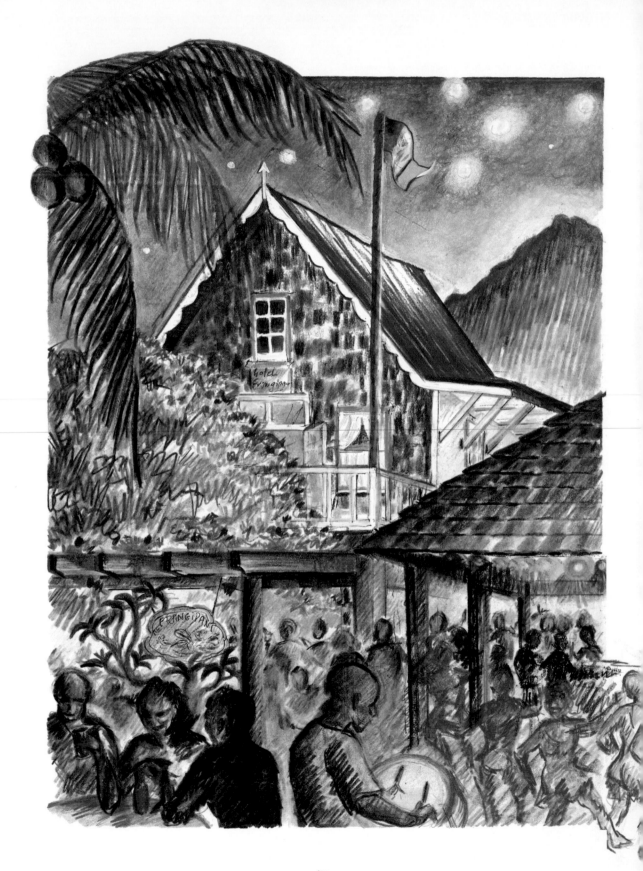

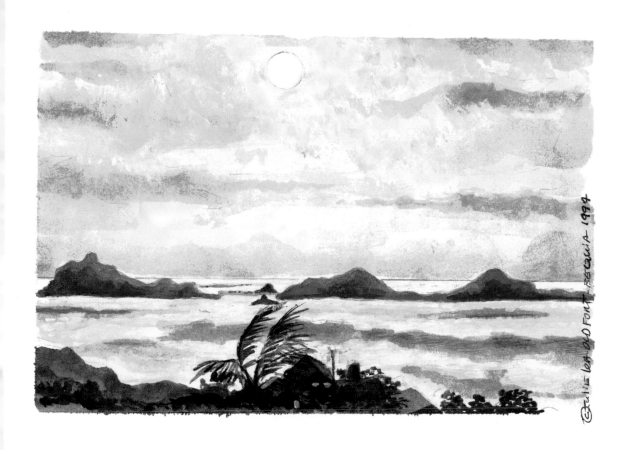

Back in Port Elizabeth a steel band plays
for a 'Jump-Up' celebration
that echoes throughout the moonlit night.

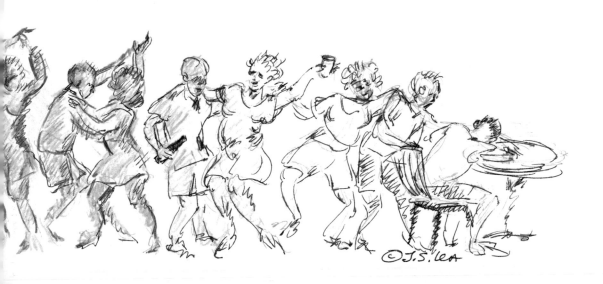

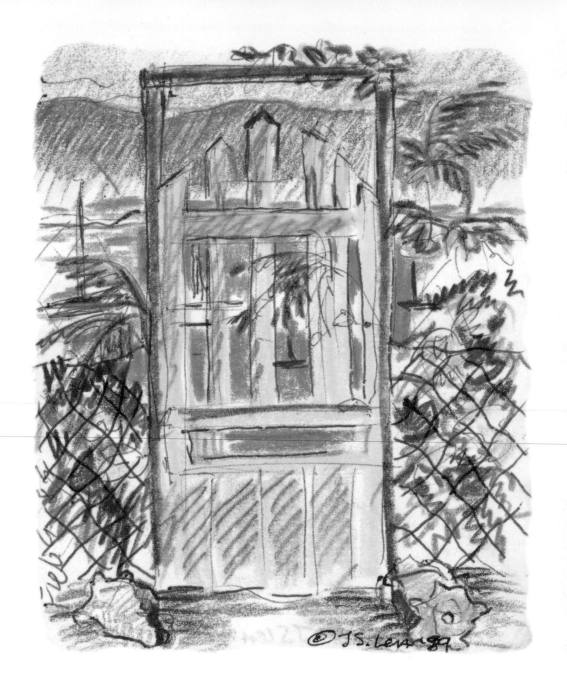

For every visitor each new morning becomes
a bright gateway of discovery ...

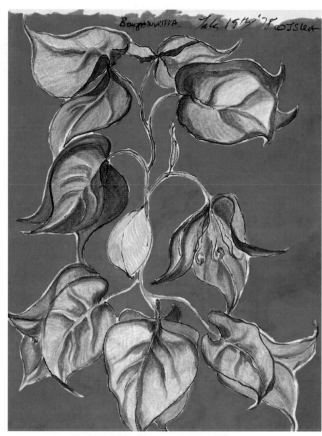

from the smallest details of reality ...

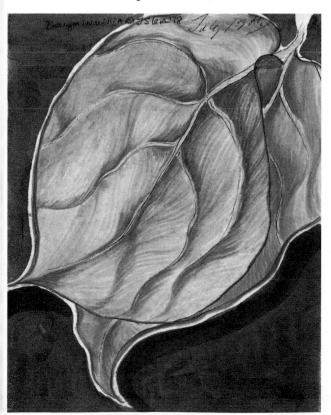

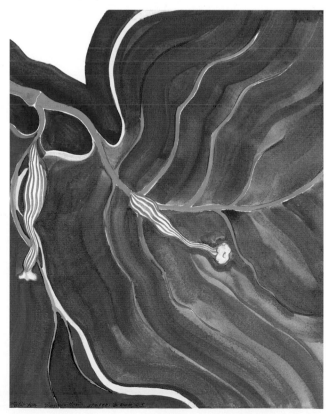

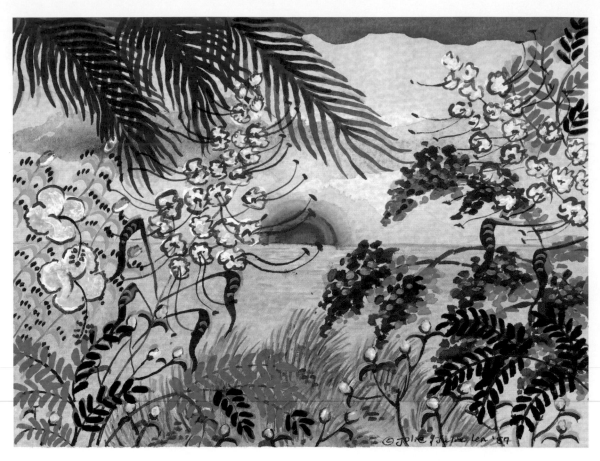

to the grandest tropical fantasies.

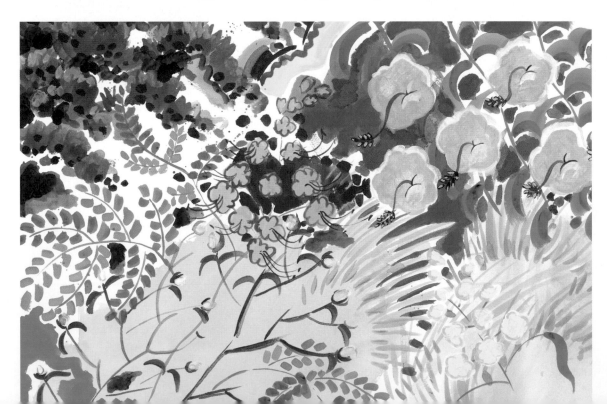

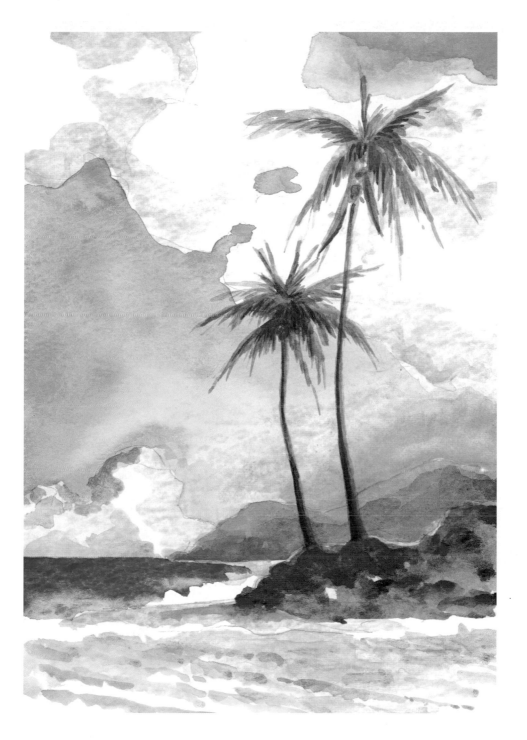

*Bequia casts her timeless spell
on all who reach her distant shores.*

List of Artwork